D0668149

CATS

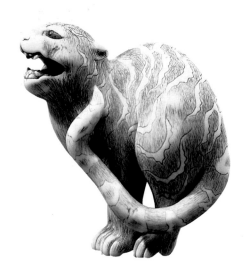

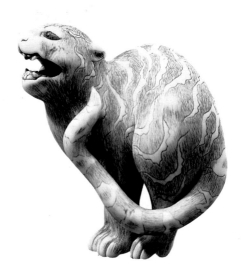

THE BRITISH MUSEUM

LITTLE BOOK OF
CATS

INTRODUCTION

Cats abound in the collections of the British Museum. They can be found in stone and bronze, ceramics and ivory, pen and ink, and they come from all ages and from all over the globe. Even in this tiny selection we cover a span of almost four millennia and glimpse many of the great civilisations of the world, from Egypt during the 18th Dynasty to Ashurbanipal's Nineveh, and from Roman Britain to 19th-century Japan.

Many of the large cats featured in these pages have symbolic or religious significance. The Assyrian lioness represents a threat to order, while the Japanese artist uses a tiger to convey the authority of an effective ruler. For the Romans, the tiger appears in a religious context as the mount of the god Bacchus, triumphant in India. The leopard of Benin, king of the forest, is traditionally regarded as the equal of the Oba, the human king of the city, and it has been suggested that the ocelot, as a 'Feathered Feline', may play a

part in the pre-Hispanic mythology of the Mexican highlands. Nowadays many of the large cats are fighting for survival, and the African lion and Bengal tiger adorning modern banknotes remind us – perhaps too late – that such creatures should be prized.

The Egyptians were the first to domesticate cats, so it is not surprising that the earliest objects in the *Treasury*, as well as possibly the most familiar, should be from ancient Egypt. Relatives of these cats appear later in Italy on Greek vases and are then taken up by artists throughout Europe for their strong decorative qualities and vitality. This fourth *British Museum Pocket Treasury* is an unashamed celebration of the cat in all its moods: the dignified, the endearing, the curious and the comic.

GAYER-ANDERSON CAT

EGYPTIAN, *c*.600 BC

This bronze replica of a cat was made in about 600 BC as a votive offering to the cat-goddess Bastet, daughter of the sun-god. The ancient Egyptian cat had become fully domesticated more than a thousand years earlier and is perfectly at home as a pet in a number of scenes which survive from the New Kingdom (*c*.1550 BC) onwards. The animal came to be regarded as sacred because Bastet, who at first had taken the form of a strong and fearless lion, was later considered to exhibit also the peaceful and friendly characteristics of the cat. Countless cat images were made in her honour, some crude and homely, others crafted to perfection. The one shown here, with its gold nose- and ear-rings and silver inlay necklet, is exquisite. On her forehead she bears a scarab representing the sun-god, on her chest the powerful *wedjat*-eye amulet of Horus, and below that a hawk-winged scarab pushing the sun-disc across the sky.

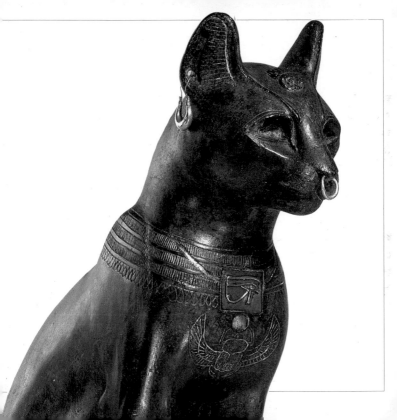

This monumental painting of a tiger by Kishi Ganku (1749-1838) is executed in ink and colours on silk and mounted to form a hanging-scroll. Japan has no native tigers and rather than seeing them as a threat they were idealised for their courage and strength. In classical Japanese art they appear as an abiding symbol of authority and power. In this work the tiger itself is painted in Chinese Ming style, with great attention to detail, for example in the treatment of each individual hair; however Ganku combines this delicacy with his own idiosyncratic style of brushwork in the dashing, almost abstract quality of the rocks and water. As there were no live large cats available as models the artist probably had to work from a skin, but he nevertheless gives a wonderful impression of life and movement by the placing of the tiger's paws, in particular the one visible hind-paw, and the wisp of tail-tip as the creature comes snarling towards us over a rocky outcrop.

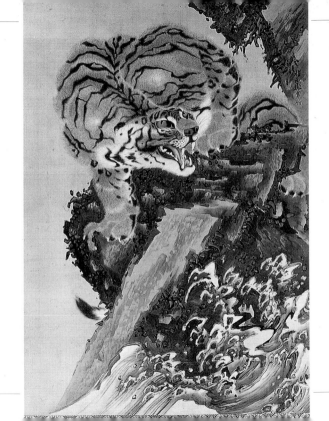

LITTLE GIRL WITH CAT

FRANCESCO BARTOLOZZI, 1787

Francesco Bartolozzi (1728-1815) first came to London in 1764, having built up a reputation within Europe as an engraver who used the colour-stipple technique of shading with dots. The fashion for prints based on master paintings was growing and Bartolozzi's skills were much in demand. Stippling gave a soft effect particularly suitable for romantic subjects such as we have here: the first, and perhaps the best portrait of a child after Reynolds which Bartolozzi produced. Unlike some artists Reynolds never objected to Bartolozzi's tendency to 'improve' on his material. His version of the *Little Girl with Cat* adds a quote from Dryden, 'Indulge her Childhood, and the Nursling Spare'. From the warm browns and beiges of the overall colour scheme the light picks up on the little girl's rosy cheeks and the unusual pale ginger coat of the kitten, which is at that stage when it will just fit comfortably into a pair of cupped hands. The cat's contentment and the child's glee are perfectly matched.

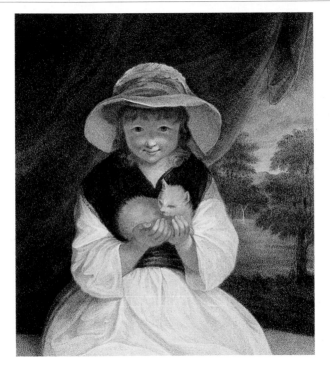

DELFTWARE CAT JUG
ENGLISH, 1674

This moulded jug in the form of a seated cat, just over 16 cm in height, was produced in Southwark, London, in 1674. Tin-glazed earthenware, which became known as delftware in England, originated in the Middle East and reached England via Spain, northern Italy and Antwerp in Flanders. The first Protestant Flemish potters, fleeing religious persecution under the Spanish Inquisition, settled in East Anglia from the 1570s onwards. Cat jugs were probably made between the 1650s and the 1670s and were associated with marriage and fertility. This one is undoubtedly commemorative: emblazoned on its chest are the initials BR.E for Richard Bazer, a brewer of St Giles Cripplegate, and Elizabeth (Hancock) of St Botolph's Aldgate, who were married on 8 December 1674.

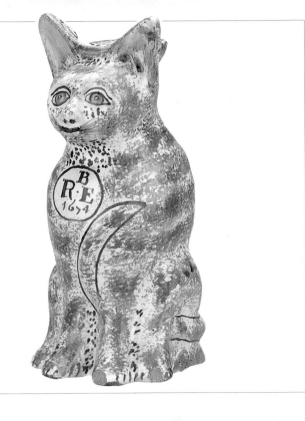

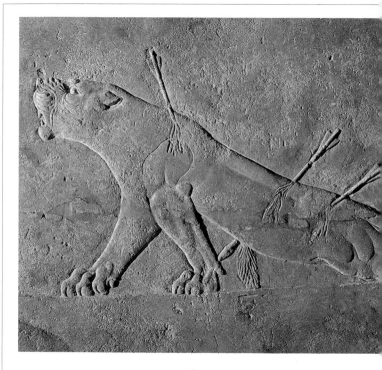

DYING LIONESS

ASSYRIAN, *c*.645 BC

The dying lioness appears in the lion-hunt reliefs from the walls of the palace of Ashurbanipal at Nineveh. The wounded beast valiantly attempting to struggle to her feet may command our respect today, but we should remember that for the early Assyrians lions represented a cruel threat to civilisation. By Ashurbanipal's time lion-hunting had become a sport rather than a necessity, and in these ceremonial carvings the animals are shown in symbolic contrast to the order and power of the king. The sculptor's chisel has left nothing to the imagination: gore spurts from the arrow wounds as the lioness grimaces in her death throes. Some would argue that the sculptor was showing sympathy for the animal's suffering rather than, or perhaps as well as, admiration for the king's unassailable dominance.

DESSINS SANS PAROLES DES CHATS
THÉOPHILE STEINLEN, 1898

The Swiss-born artist Théophile Steinlen (1859-1923) moved to Paris in 1881 and was almost as celebrated as Toulouse Lautrec in his day. He was prolific in his paintings, book illustrations and poster designs of a wide range of subjects, including cats, although nowadays his reputation rests chiefly on his large-format book, *Dessins sans Paroles des Chats*, of which this is the front cover. The book contains a number of 'stories without words', such as 'The Awful End of the Goldfish'. Here the little girl bearing a bowl of milk has inevitably become the centre of attention. Not only has Steinlen rendered a variety of coat-colourings, from striped and blotched tabby to tortoiseshell, he has shown himself to be a master of cat body-language, proving that words are not necessary when there are questioning tails, stretched legs and arched backs to reinforce the persuasion of miaows.

Two Rupee Note

India, 1983

This two rupee banknote, issued in 1983, shows on the back left a Bengal tiger with, in a small roundel below, a full side-view of the animal on the prowl, the emblem of the Reserve Bank of India. Its appearance on the note is a constant reminder of the sad fact that this species is currently threatened with extinction. Unlike the sternly dignified lion on the South African note (see page 56), this snarling tiger is shown roused to defensive action, its right ear flattened, incisors bared and whiskers bristling, the picture of ferocious strength and energy. The front of the banknote and the watermark show the armorial bearings of India, the Ashoka column capital which has four carved lions facing out in the four directions with, below, the wheel of the Buddhist Law.

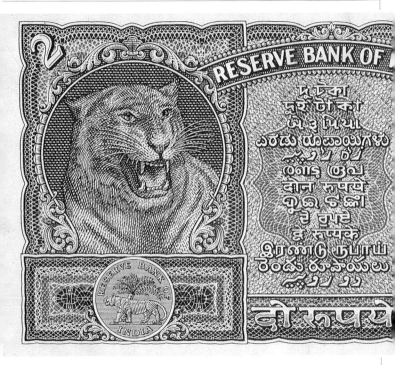

MUMMIFIED CAT

EGYPTIAN, AFTER 30 BC

The cult of the cat-goddess Bastet had become particularly popular during the Ptolemaic period (332-30 BC) and continued to flourish in Roman Egypt. There were large colonies of cats attached to the temple of Bastet at Bubastis, which had an immense cemetery. This mummy was excavated at another of the large cemeteries, at Abydos in Upper Egypt. It is a fine product with elaborately interlaced bindings in the 'meander' pattern, a technique similar to that used for human corpses at the time. Surprisingly, few of the mummified cats which have been examined were over two years old at death, which suggests that they may have been killed on purpose to fulfil the great demand for cats as votive offerings. After excavation in the late 19th century shiploads of mummified cats of up to 19 tons at a time were imported to this country – only to end up as fertiliser. That this one has survived at all is something of a miracle.

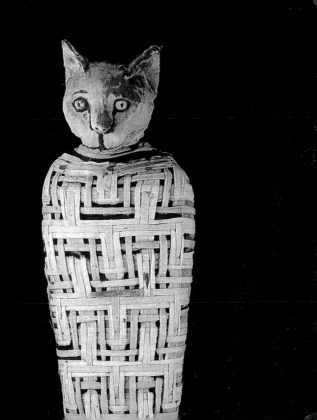

SIAMESE CATS

CHRISTOPHER WOOD, 1927

The tragically short-lived artist Christopher Wood (1903-1930) is perhaps best known for his paintings depicting the lives of Cornish and Breton fishing communities. However, his distinctive drawings include this chalk sketch of two Siamese cats which may have belonged to the artist Jean Cocteau, whom Wood met in Paris in 1924 and who is known to have kept such animals. The natural features of this hot-climate breed – pale colour, short smooth coat, large ears and slim tail – result in the elegant appearance for which the Siamese cat is especially prized. Wood has caught the cats' intensity and grace to perfection in this lightning sketch. His spare use of curved lines indicating the background effectively continues the horizontals and diagonals of the cats' backs, and the whole is balanced by the areas of colour dashed on at the last minute, not least the unfaltering blue of the cats' gaze.

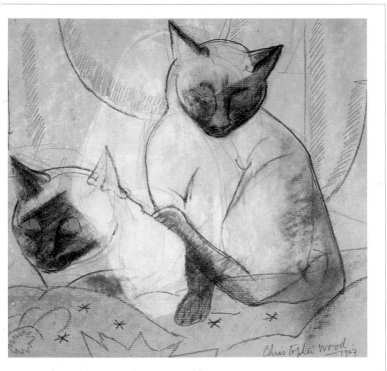

Christopher Wood
1927

Kawanabe Kyōsai (1831-89) was a highly talented eccentric, who seems to have acquired his penchant for depicting cats through an early studentship with the cat lover Kuniyoshi. There is something sinister about the breathless desperation of this scene, which has all the trappings of what should be a joyous Shintō religious festival. The baleful cat in Shintō priest's headgear perches inexplicably on a melon drawn by frantic mice, while the attendant white cat has the forked tail of a malevolent spirit. The whole scene is brought to a pitch of frenzy by Kyōsai's faultlessly energetic brushwork.

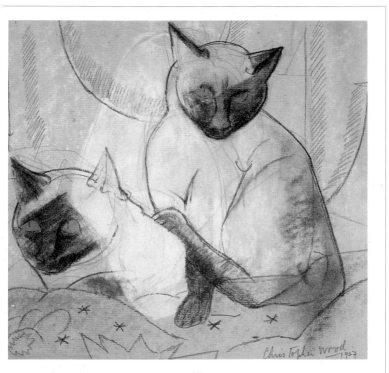

Christopher Wood
1927

CAT SEATED ON A MELON
DRAWN BY MICE
KAWANABE KYŌSAI, 1879

Kawanabe Kyōsai (1831-89) was a highly talented eccentric, who seems to have acquired his penchant for depicting cats through an early studentship with the cat lover Kuniyoshi. There is something sinister about the breathless desperation of this scene, which has all the trappings of what should be a joyous Shintō religious festival. The baleful cat in Shintō priest's headgear perches inexplicably on a melon drawn by frantic mice, while the attendant white cat has the forked tail of a malevolent spirit. The whole scene is brought to a pitch of frenzy by Kyōsai's faultlessly energetic brushwork.

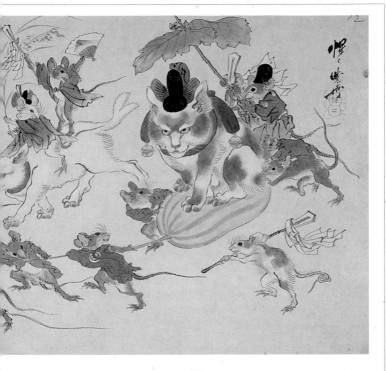

Hoxne Tigress

Roman, 4th Century AD

The Hoxne tigress, 16 cm long and weighing nearly 500 g, is outstanding among the silver objects recovered from the impressive Roman treasure hoard found in Hoxne, Suffolk, in 1992. The tigress is not an independent statuette but would have formed one of a pair of handles from an amphora-shaped silver vase; she may have been matched with a similarly prancing tiger, but neither tiger nor vase was hidden in the treasure chest. Two vases with similarly ornate handles are known, one in particular decorated with scenes of Bacchic revelry, and it seems reasonable to suppose that a lost Hoxne vase may have been ornamented in the same way. The tigress herself is engraved with stripes inlaid with niello, and the conspicuous teats leave us in no doubt as to her sex. What is clear is that, although female, she can be as ferocious as necessary when defending her young and her determination is expressed in the extended claws, flattened ears and bristling beard.

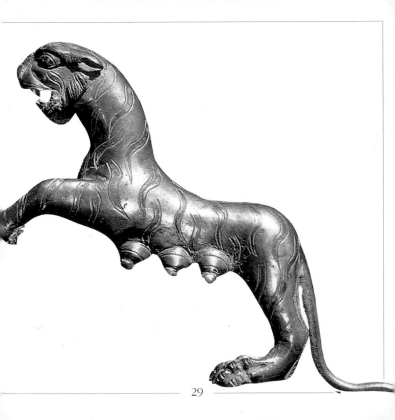

STANDING LIONESS

PETER PAUL RUBENS, *c*.1615

This detail is of a masterly study by Rubens (1577-1640), in black and yellow chalk with white highlighting, made in preparation for his painting, *Daniel in the Lions' Den*, now in the National Gallery of Art, Washington DC. Before embarking on a large painting Rubens would often first make a small-scale oil sketch, then work on the main figures in a series of studies. This lioness appears on the extreme right of the painting, snarling at a lion. It is thought that Rubens used a sixteenth-century Paduan bronze sculpture as a model, a common practice when the pose, as here, involved foreshortening and movement. The solidity and vigour of the image is accentuated by the scratchy dark lines across its back and the dashes of white highlighting dragged swiftly across the flanks and tail. Where possible Rubens also drew captive animals from life, probably in the menagerie of the Archduke Albert in Brussels.

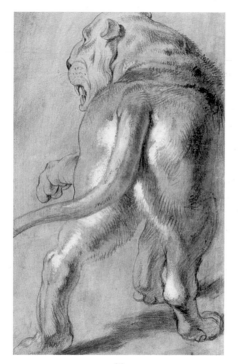

FOWLING IN THE MARSHES

EGYPTIAN, *c*.1400 BC

This is one of a group of Theban tomb-paintings known as 'cat in the marshes' paintings. In this example from the tomb of the official Nebamun, the cat is particularly active, having got its teeth and claws into three birds at once whilst balancing precariously on two papyrus stalks. Here is a very realistic, somewhat western-looking cat with its long whiskers, striped orange coat with stippled hairs raised in excitement, and even the pads of its paws clearly visible. It is not known why cats are so often present in such scenes. One theory is that they were used as retrievers, or at least to flush birds from their nests. Another takes the paintings as evidence of the degree to which cats had become part of the family since domestication: not only does the hunter take his wife and daughter with him on his fowling expeditions, but the family cat is brought along too. Or is its presence purely symbolic, indicating fertility and prosperity?

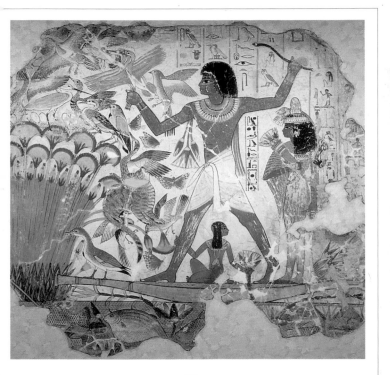

PAIR OF IVORY LEOPARDS
BENIN, 19TH CENTURY

This pair of ivory leopards from the kingdom of Benin on the west bank of the Niger was sent to Queen Victoria in 1898 by Admiral Rawson and is now on permanent loan to the British Museum. Leopards figure prominently in Benin art and culture because, as kings of the forest, they correspond to the position of the Oba, or king, as head of the town. There was a separate guild of leopard-hunters who captured live animals for the Oba to sacrifice at special ceremonies; or they were tamed using charms and paraded in processions to demonstrate his dominance. Each of these statues is carved from five sections of ivory, a royal material. The spots are said to have been made from copper percussion caps from 19th-century rifles, a good example of how Benin craftsmen saw foreign imports as raw materials to be harnessed in the service of their empire.

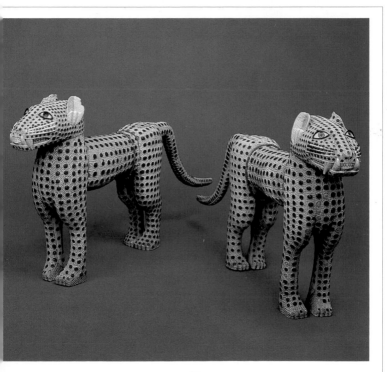

Just over one metre in diameter, this mosaic roundel formed the centre of a Roman pavement found in Leadenhall Street in the City of London. The Romans adopted a number of mystery cults, including those of the Egyptian Isis, the Persian Mithras and the Greek Dionysos, or Bacchus, and these existed side by side with the official religions of the Roman state. Usually Bacchus is accompanied by a panther, but the strongly-striped coat of this high-stepping feline clearly declares it a tiger, indicating that the mosaic celebrates an aspect of the Indian Bacchus, who is always depicted riding a tiger. It is not surprising that London, an important capital, commercial centre and port in Roman times, should have yielded up evidence of a wide range of religious practices, including the ecstasy-generating revelries of Bacchus, shown here negligently dangling his empty wine-cup whilst the tiger appears gently to nuzzle his arm.

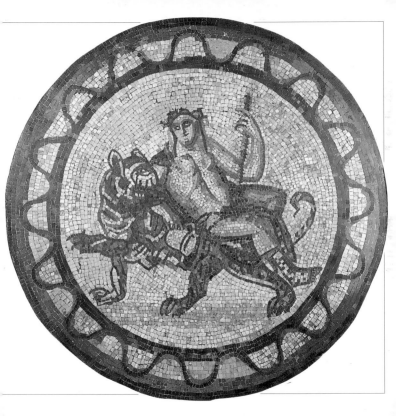

VIRGIN AND CHILD WITH CAT
LEONARDO DA VINCI, LATE 1470s

Leonardo da Vinci (1452-1519) made three sheets of studies for a painting which he seems to have had in mind in the late 1470s, of which this is one. No finished painting of the subject is known, but it may be that the *Madonna Benois* in the Hermitage, where Christ plays with a flower, grew out of these sketches. This suggests that Leonardo was interested in the idea of a child at play generally, rather than specifically with a cat. He was faced with the problem of finding a form to fit the basic arch-shaped structure, and the drawing gives an absorbing insight into the artist at work in pen and ink, continually making changes which involved trying out three positions for the Virgin's head. Even in this tiny study the determination in the splayed fingers of the child's left hand and the desperation in the cat's left paw braced against his shoulder are deftly shown.

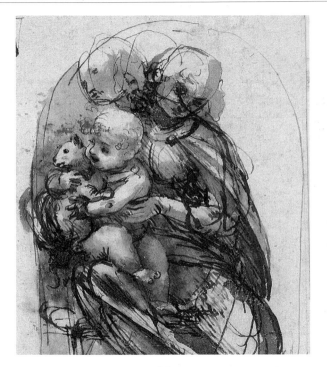

CAT LOOKING AT FIELDS AT ASAKUSA

ANDŌ HIROSHIGE, c.1856

Hiroshige (1797-1858), like many Japanese print artists, often designed sets of prints on a theme, and this series, *One Hundred Famous Views of Edo* (the old name for Tokyo), is one of the best known. Few animals are portrayed in the *Views*, but Hiroshige perhaps chose to feature a cat here to emphasise the serenity of the interior in contrast to the noisy revellers passing in procession in the distance. They are celebrating the year-end Festival of the Cock at the Washi Daimonji Shrine, no doubt buying *kumade*, lucky bamboo rakes to ensure business success in the coming year. The auspicious shape of Mount Fuji stands against the sunset as a flight of geese passes overhead, making an angle with the line of cheeky sparrows pictured behind the cat's back. The cat is a bobtail, a kind much favoured by the Japanese, who feared that the long-tailed variety might turn into fork-tailed witch-cats.

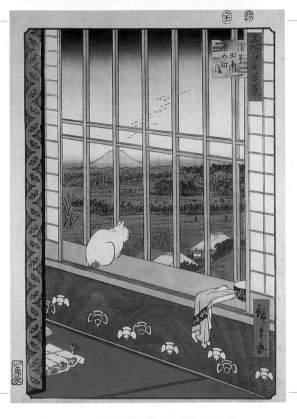

GREEK VASE

c.330 BC

This red-figured *lebes gamikos* (cosmetic vase) showing two women playing with a cat comes from Avella in Campania in southern Italy. Greeks had been settling in southern Italy and Sicily from about 730 BC, bringing with them their own ways of life, including their arts and crafts. The first red-figured vases of Campania were probably produced by potters and painters from Sicily in about 370 BC; this vase dates to around 330 BC. The two female figures on this vase may be mythical subjects – Aphrodite and Peitho – but this is clearly a domestic scene. The cat seems to be a mixture of striped and spotted tabby and its avid eagerness to reach the bird held up as bait by the naked woman on the right may remind us of the much earlier Egyptian cat in the marshes (see page 33). This woman also has a ball of wool or a yo-yo, while her companion has brought another toy with which to amuse their lively cat.

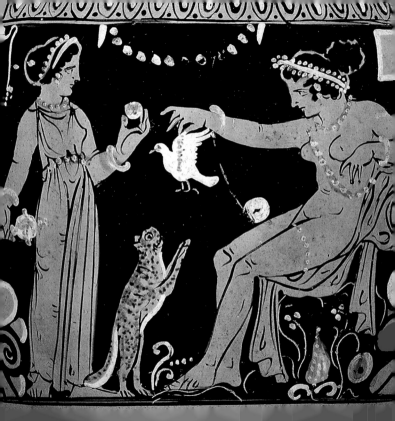

A netsuke is a toggle that was knotted on to the end of the braid used to attach an *inrō*, a small container for pills and other minor items, to a man's sash. As with much classical Japanese art, it served both a practical and an ornamental purpose. Here, the cord would probably have passed through the tiger's mouth. The Japanese craftsman's strong decorative sense, linked with a relentless perfectionism ensured that even small, inconspicuous items were lavished with care and attention. This tiny ivory tiger, only 4.4 cm high but taut with ferocity, will nestle comfortably within the palm of the hand. Not only is the body boldly striped, but even the individual hairs are incised into the surface. The carver has captured perfectly the spirit of the creature with its amber-inset eyes and arched back, roused to spitting fury. It would probably have been worn in the zodiacal Year of the Tiger, or by someone born in a Tiger year.

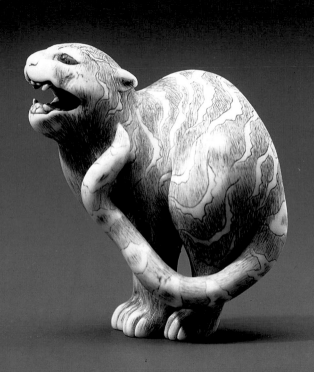

PUSS NAPPING

GEORGE BAXTER, 1856

George Baxter (1804-67) produced some of the earliest colour prints using a unique method of woodblock printing which he patented in 1835. This picture of a tabby was produced at the height of his career, following his success at the Great Exhibition of 1851 where, under the patronage of the Prince Consort, his stand was one of the wonders of the fair. Baxter's technique of using a steel plate and four colour-blocks produced a high degree of definition, which is noticeably successful here in rendering the finely-striped flanks and impressive necklaces of the sleeping cat. The method also allowed for the subtly graduated background of storm-blue sky which brightens to the left and sets off the tabby and the tiny mice with their thread-like tails.

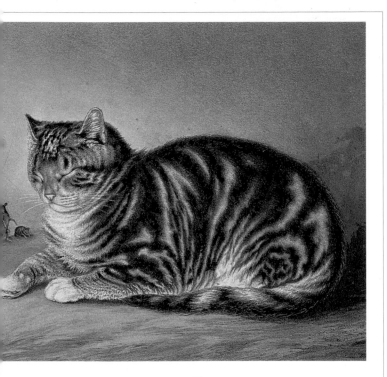

PUSS-IN-BOOTS

WALTER CRANE, 1870

Walter Crane (1845-1915) regarded children's book illustration as a serious art in its own right, capable of stimulating and enriching the child's imagination. In the early 1870s he designed a number of books for the publisher Routledge in its 'Toy Books' series, including the tale of Puss-in-Boots. This is the design for page one in pen and brush with Indian ink. The small space is filled with carefully organised activity, not unlike the style of a medieval manuscript: at the top we see the fortunate older brothers with their inheritance of mill and ass; below the bridge are family groups of swans and ducks, whilst in the foreground the outcast youngest son sighs, 'Alas! I must starve now, unless I take Pussy to eat!' The design is dominated by the solid black figure of Puss, the cat magician, who with his quick wits is to make both their fortunes.

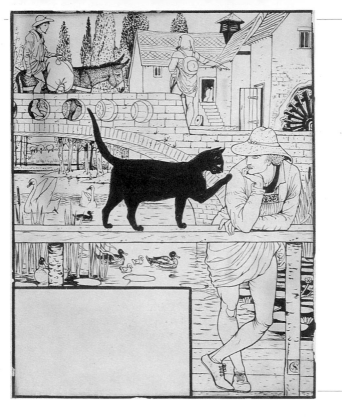

SATIRICAL PAPYRUS

EGYPTIAN, *c.*1400-1200 BC

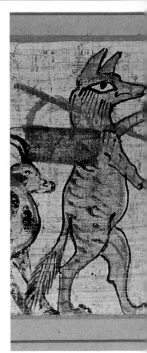

On this papyrus sheet, probably from the Theban necropolis of Deir el-Medina, the sure hand of the artist brings us a rare glimpse of ancient Egyptian humour. The painter expresses his view of the world by turning it upside down, peopling it with animals who act like humans. The cat goes boldly to its task, confidently two-legged, waving its stick as the geese proceed obediently ahead. The same device of cat as gooseherd appears elsewhere on the sheet, but there the geese are not so docile!

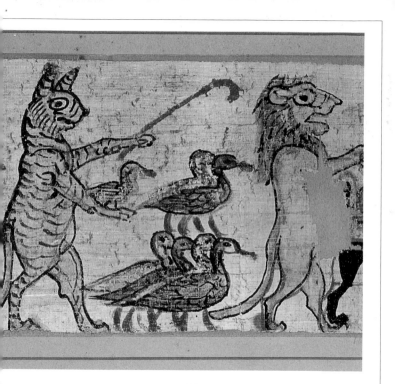

Offering Vessel in the Form

of an Ocelot

Mexico, 150 bc - ad 750

This unique vessel is made from the semi-precious stone onyx and comes from the city of Teotihuacan in the Central Highlands of Mexico. It was used in seasonal ceremonies intended to invoke rain and to ensure a plentiful harvest. The feline depicted is likely to be an ocelot, which is native to the high mountain basins of the region. Partly because of the nature of the stone used the horizontal and vertical elements of the figure have been emphasised, producing a flattened effect. An unusual feature of the sculpture is the zigzag edging to its forelegs which may represent feathers: it may therefore best be described as a 'Feathered Feline', akin to the 'Feathered Serpents' which feature prominently in the mythology and art of Mexico's pre-Hispanic civilisations.

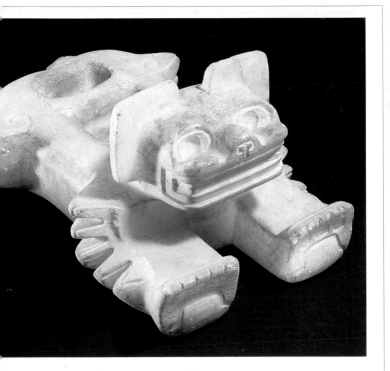

CAT AND GOLDFISH

ISODA KORYŪSAI, *c.*1760-80

Koryūsai was a prominent Japanese woodblock artist and painter of the ukiyo-e, or 'floating world', school as it approached its zenith in the late eighteenth century. Like most artists of this school he concentrated on producing images of beautiful women splendidly attired in silk kimonos for the entertainment of Edo townsmen. Here, however, he has turned his attention to a pampered cat. This print appears to be a light-hearted parody of a Chinese-style tiger painting: the pose is familiar, with the hunched shoulders and twitching tail. The comparison is made the more incongruous by the cat's adornments. A potted bonsai represents an ancient gnarled pine tree, and the raging waterfall becomes a churning bowlful of frightened goldfish as Koryūsai gives this universal theme his own very individual treatment.

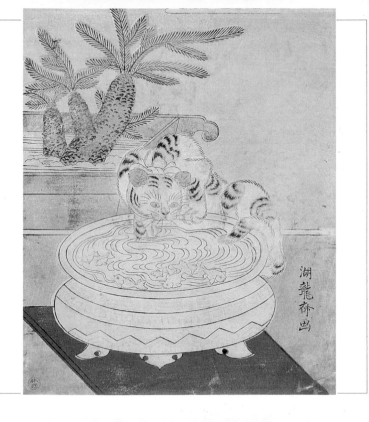

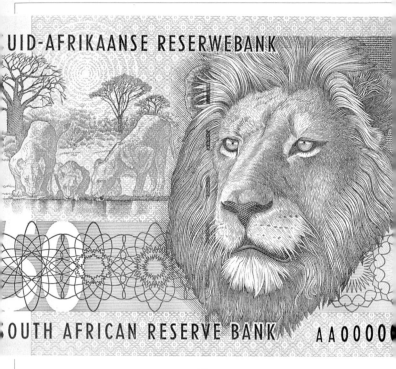

UID-AFRIKAANSE RESERWEBANK

OUTH AFRICAN RESERVE BANK AA0000

50 RAND NOTE

SOUTH AFRICA, 1993

In 1993 the South African Reserve Bank began to issue the first new series of notes since 1978. The five notes designed by South African artists show the country's five foremost indigenous creatures: the lion, the elephant, the rhinoceros, the buffalo and the leopard, with scenes of economic activity on the back. Appropriately enough, the first of the new notes shows the King of Beasts, nobly and realistically depicted with a fine regard for minute detail. The head is produced by intaglio printing so that it literally stands out from the paper. This is not only useful as a precaution against counterfeiting, but also enhances the impression of grandeur. The lion's head appears in reverse on the front left of the note as a watermark. Between the two is a beautifully-realised scene of two lionesses and a cub drinking at a water-hole.

TIGERS IN A BAMBOO GROVE
UTAGAWA KUNIYOSHI, 1844

The Japanese woodblock artist Utagawa Kuniyoshi (1797-1861) often depicted Chinese subjects, and this is one of a series of *giga*, or 'humorous pictures', treating the Chinese zodiacal cycle of animals in a highly irreverent way. The tiger, the third in the twelve-year cycle, was generally regarded as the embodiment of the male principle of strength and reliability, while the bamboo represented a complementary gentle strength which bends but will not break, and the two are often combined symbolically in classical Japanese art. Here, however, the curious half-animal, half-human hybrids are shown tumbling about in a drunken riot, trampling the tender bamboo shoots.

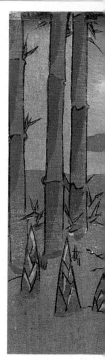

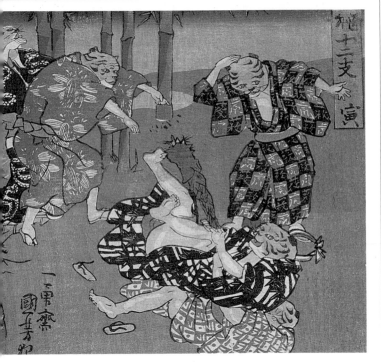

ACCESSION NUMBERS OF OBJECTS ILLUSTRATED

First published in 1996 by The British Museum Press
A division of The British Museum Company Ltd
38 Russell Square, London WC1B 3QQ

Reprinted 2005, 2006, 2007, 2008
Paperback edition 2004

A catalogue record for this book is available from the British Library

ISBN 978-0-7141-5027-7

Text by Mavis Pilbeam
Photography by the British Museum Photographic Service
Designed by Butterworth Design
Cover design by Harry Green

Typeset in Garamond
Printed in China
by Hing Yip Printing Ltd